D1539764

PEDAL POWER

HOW A MOUNTAIN BIKE IS MADE

PHOTOGRAPHS AND TEXT BY
DAVID HAUTZIG

Lodestar Books

Dutton New York

LIBRARY OF CONGRESS CATALOGING-IN-PUBLICATION DATA

Hautzig, David.
 Pedal power: how a mountain bike is made/photographs and text
by David Hautzig.—1st ed.
 p. cm.
 Summary: Describes different kinds of bicycles, especially mountain
bikes, and their various parts, the materials from which they are
manufactured, how to care for a bike, and safety tips for riders.
 ISBN 0-525-67508-6
 1. Bicycles—Juvenile literature. [1. Bicycles and bicycling.] I. Title.
TL400.H38 1996
629.227'2—dc20 95-14855
 CIP

Published in the United States by Lodestar Books,
an affiliate of Dutton Children's Books,
a division of Penguin Books USA Inc.,
375 Hudson Street, New York, New York 10014
Published simultaneously in Canada
by McClelland & Stewart, Toronto

Editor: Virginia Buckley Designer: Joseph Rutt
Illustration by David Hoffer
Printed in Hong Kong
First Edition
10 9 8 7 6 5 4 3 2 1

thanks to my personal manufacturers

Roxane Frechie and Robert Tirman

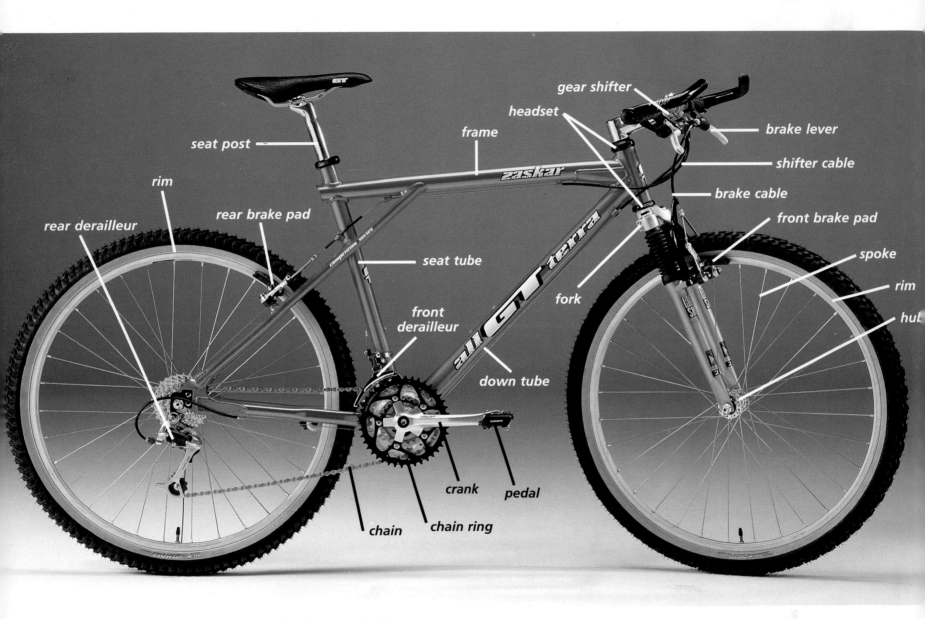

seat post

rim

rear derailleur

rear brake pad

gear shifter

headset

frame

brake lever

shifter cable

brake cable

front brake pad

spoke

seat tube

rim

fork

hub

front derailleur

down tube

chain

chain ring

crank

pedal

A fully assembled mountain bike

A bicycle means different things to different people. It can be something to ride for fun on a sunny day. Or it can be a great form of exercise. For those who do not have a car, it may be their only form of transportation. In China, very few people own cars. Almost everyone, however, has a bicycle. China produces more bicycles than any other country in the world: over forty million per year!

Bicycles have changed a lot over the years. New advances in technology have brought many improvements. Bicycles now are lighter, stronger, and faster than ever before. But what did the first bicycle look like?

The great Italian artist Leonardo da Vinci drew some sketches in the fifteenth century of a machine that resembled a bicycle. In 1816, Baron Karl von Drais built the earliest known two-wheeled vehicle, or bicycle. It was made out of a wooden bar with a seat attached to two wheels. The rider went forward by pushing his feet backward against the ground. Years later, in Scotland, a blacksmith named Kirkpatrick Macmillan built a two-wheeled machine with pedals connected by a rod. When the rider pushed the pedals, the back wheel turned. This was the first bicycle that allowed the rider to move forward without his feet touching the ground.

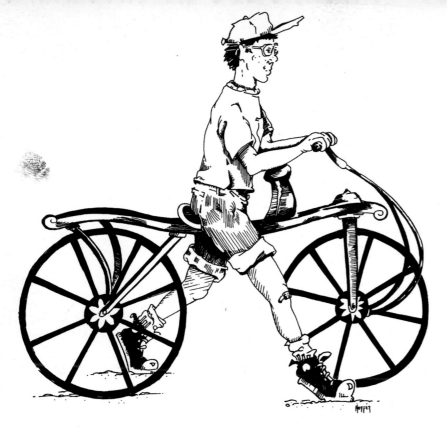

Baron Karl von Drais's original bicycle, called the Draisine

Today, bicycles are made in factories by machines designed specifically to build bicycles. One of these places is the GT Bicycles factory in Huntington Beach, California.

Many different types of bicycles are built at GT, including mountain bikes. Around 1978, a group of bicycle racers in California wanted a bike they could ride through the woods. The tires on their racing bikes were too thin for the rough terrain, and their only other choice was a bike called a beach cruiser, which had fat tires but only one speed. So these bicycle racers invented a new bicycle, combining the fat tires of the beach cruiser with the multiple speeds of their racing bikes. Their invention became the mountain bike, which now makes up about 70 percent of all bicycles sold in the United States. Most bicycles are made primarily of metal. Some bicycles are made of aluminum, the same metal used to

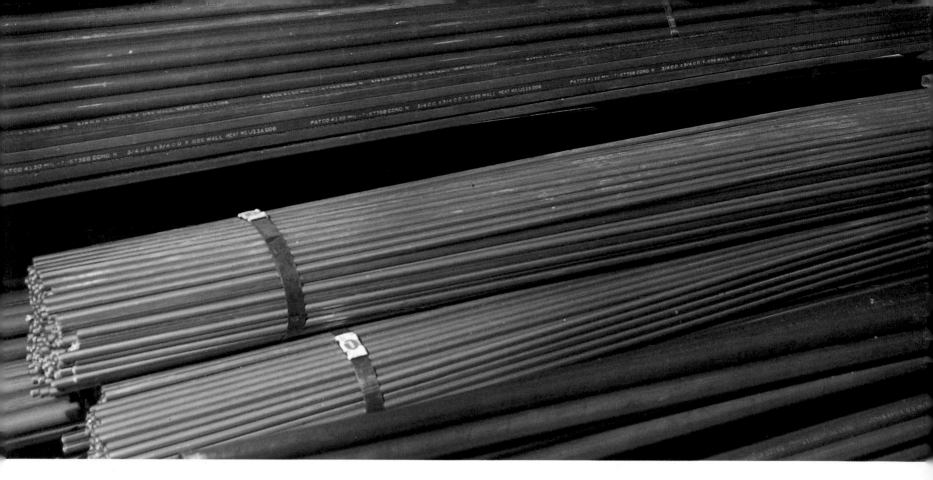

All metal tubes arrive at the GT factory as long pieces that will be cut to size later on.

make aluminum foil. You probably have some in your kitchen. Aluminum is a strong yet lightweight metal. A lighter bicycle is easier to ride, especially uphill. You have less weight to carry. Other materials used to make bicycles include steel, cromoly, and titanium. Titanium is preferred by many companies that build airplanes because it is both lighter and stronger than aluminum. Titanium is even used on the space shuttle. Some bicycles are made from composite metals, which are combinations of various metals.

Every piece of metal used to make a mountain bike is important. The largest and most important piece is called the down tube, which runs from right below the handlebars to right above the pedals. The down tube must be strong because it is the part that supports your weight when you sit on your bicycle. If it weren't strong, your bicycle would collapse underneath you.

Take a look at a bicycle. You'll notice that some pieces are bent or curved. For example, the tubes for the front fork are bent. The slight bend in the metal tubes

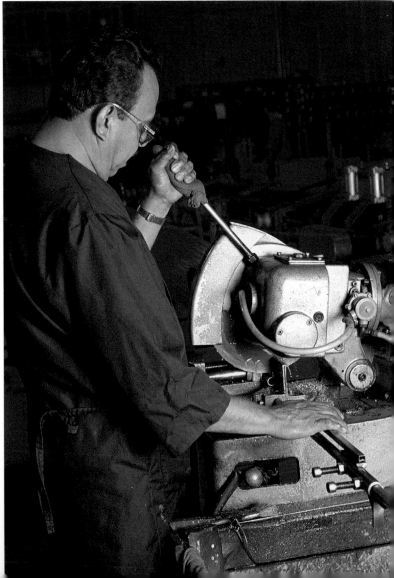

8

BELOW: *Some tubes are bent on a machine called a programmable tube bender. Tubes that are bent include the front and rear forks, and the chainstay.*

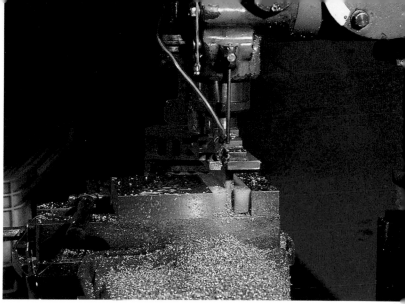

ABOVE: *Tubes are faced (made smooth) on a machine called an end mill.*

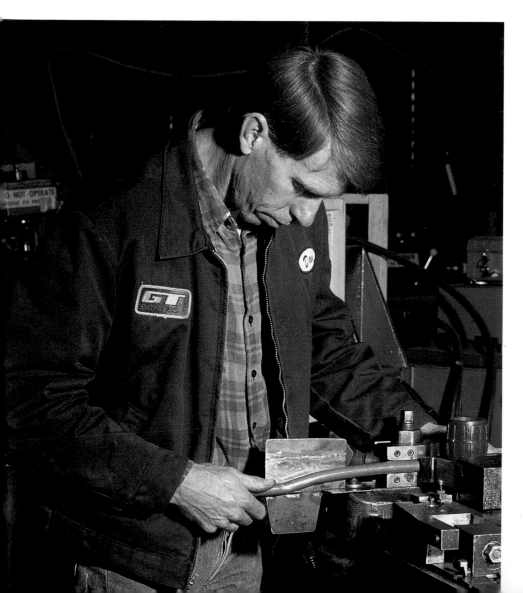

allows the fork to soak up little bumps in the road, thus making it more comfortable for the rider. Although some manufacturers use straight tubes for the front fork, the bent front fork is the more common and traditional design.

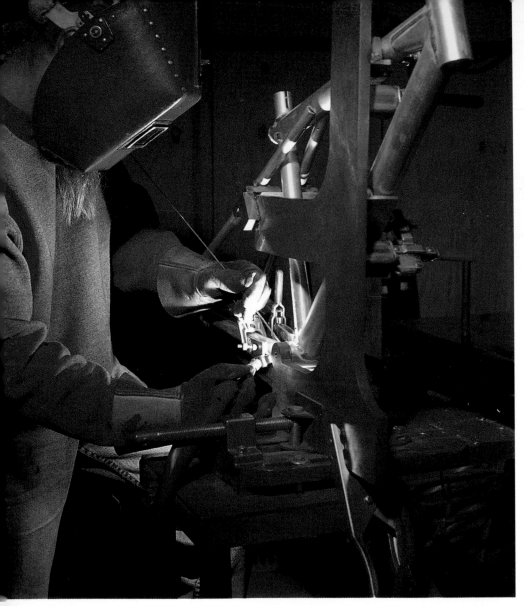

The tubes are placed in a fixture, or "jig," which holds them in the shape of a mountain-bike frame. They are then welded together.

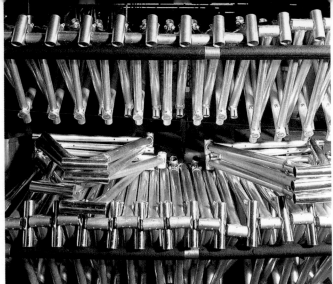

Welded frames are put on a rack to be painted or heat treated, depending on the type of metal in the frame.

For a bicycle frame to be as strong as it can be, the metal tubes that join to make the frame must fit together perfectly. Sounds simple, right? Think of it this way, however. Get two drinking straws. They are tubes, too. Now make the letter *T* with the two straws. Look at the area where the straws touch. Only a little piece of each one is touching. But if you cut a groove in the end of the down part of the *T*, the two pieces would fit together perfectly. This is called facing the tubes.

The most important step in turning the metal tubes into a mountain-bike frame is the welding process. "Welding" means joining together or bonding together, and it's a two-step process. Step number one is called tack welding, which is a simple weld that holds the tubes together in the shape of a mountain-bike frame. You can now lift the frame without it coming apart. But you wouldn't want to put wheels on it and ride just yet—not until the frame has been finish welded. That's a second, stronger weld.

Although most bicycle frames are still made of steel, aluminum bicycle frames have become very popular in the last few years. Aluminum frames are very strong and durable, but they don't weigh as much as steel frames. They're also very comfortable to ride because aluminum absorbs bumps in the road better than steel. All of this, however, comes with a certain price. Aluminum bicycle frames cost more to make because of extra steps needed in the manufacturing process, such as heat treating.

Aluminum mountain-bike frames are heat treated for maximum strength. The frames are put on a rack, then raised into an oven that heats up to 985 degrees Fahrenheit for ninety minutes. After being heated, they are placed in water to cool down. This heating-cooling process actually realigns the aluminum particles in the tubes. One more trip into an oven, this time for eight hours at 350 degrees, gives the frames maximum hardness.

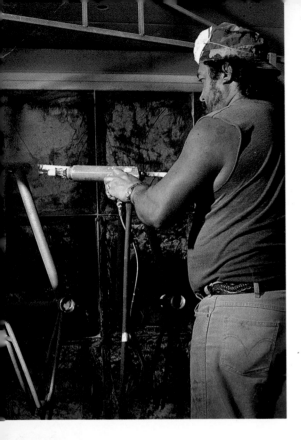

LEFT: Paint goes on a bicycle frame as a fine, dustlike powder. It can turn a dull silver frame into a shiny blue frame. Or a shiny red frame. Or almost any color you can imagine.

BELOW: After the painted frames are heated, they need twenty-four hours of cooling to reach 100 percent hardness.

Painting a bicycle isn't done with a can of paint and a brush. The paint is sprayed onto the frames with a special electrically charged spray gun. The frames are hung up on metal rods that are also electrically charged, but the charge is opposite that of the spray gun. The charge of the metal rods is transferred to the bike frames, giving them the opposite charge of the spray gun. What does electricity have to do with painting, you ask? The answer comes in a short science lesson.

When particles with a positive charge meet particles with a negative charge, they stick together. It's what happens when you rapidly rub a balloon against your hair, then put it against a wall. The balloon sticks to the wall. In the same way, powder paint sticks to the frame. But if you touched the frame with your finger, the powder would come right off. So after they are sprayed, the frames are heated. The heat makes the powder melt into a shiny, hard, plasticlike finish.

12

Now that the frames are painted and heat treated, they are ready to become mountain bikes. Frames are put on an assembly fixture, which holds them in place. This makes installation of parts easy. First, the bottom bracket is installed with a powerful tool called an air wrench.

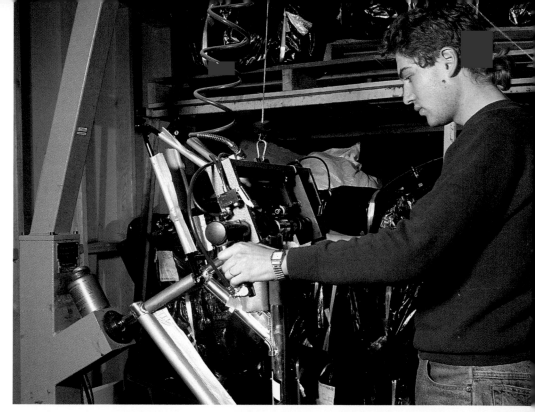

To make a bicycle move, you push the pedals with your feet. But how does pedaling make the rear wheel turn, thus enabling the bicycle to go forward? The pedals are screwed into the cranks. The crank on the right side of the bicycle is attached to a metal disc with sprockets for the chain. The chain is also attached to sprockets on the rear wheel. So when you pedal, you turn the cranks, which make the chain turn. When the chain turns, the rear wheel moves, and this lets you ride your bicycle.

The crank axle holds the cranks, into which the pedals are screwed. A chain ring attached to the right side of the bike has sprockets for the chain.

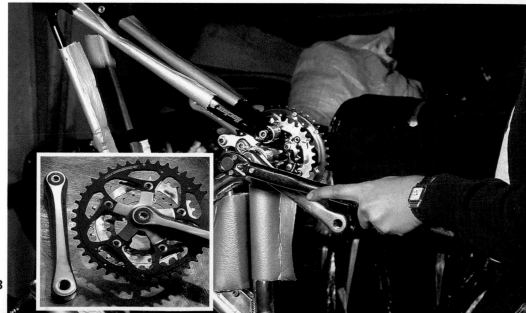

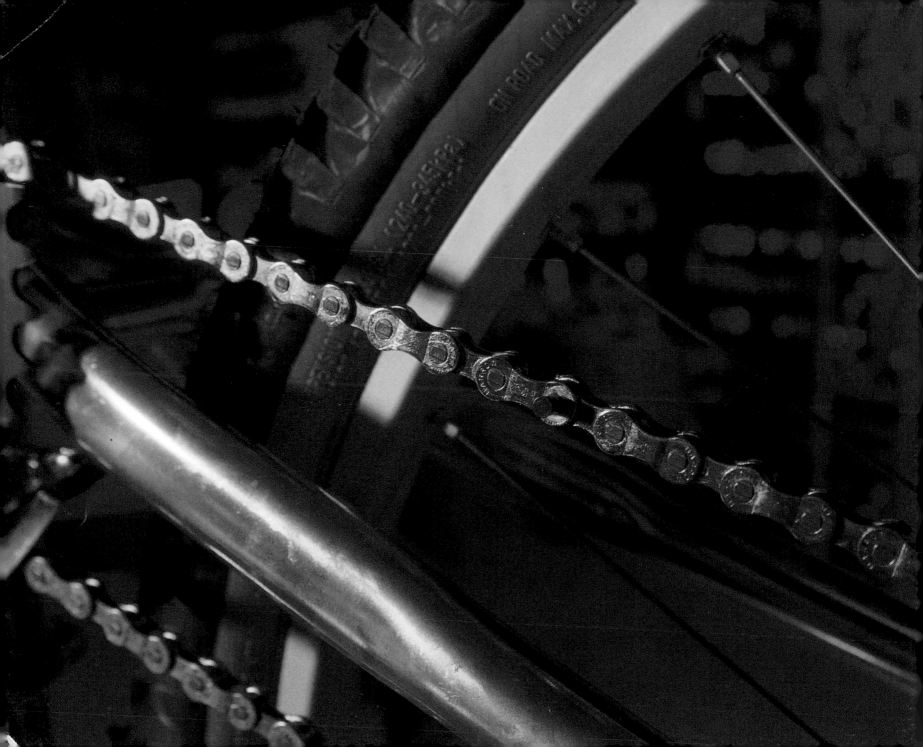

FACING PAGE: *Bicycle chains are made of steel. There is no standard length for a bicycle chain because there are many different bike sizes. A chain becomes a loop by pressing a chain pin into two chain links, thus making the chain seamless.*

RIGHT: *The cantilever brake attaches to pivots that are welded onto the rear stays of the bike. The brake has a spring on each side. When you squeeze the brake levers on the handlebars, the two pads squeeze the wheel and either slow down or stop the bicycle.*

BELOW: *Brake pads like these are used on both the front and rear wheels. Squeezing the brake levers pulls brake cables that run down the frame to a link wire. The link wire pulls the two brake pads together against the wheel.*

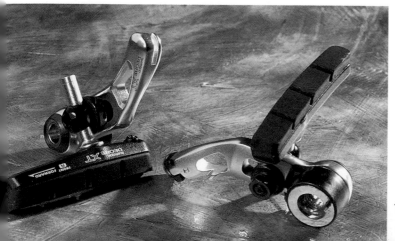

Pedals, cranks, and the chain are very important because they make the bicycle go. Brakes are even more important because they make the bicycle stop. If your brakes don't work properly, you may not be able to stop in time to avoid an accident. A good way to test your brakes is what I call the "mushy" test.

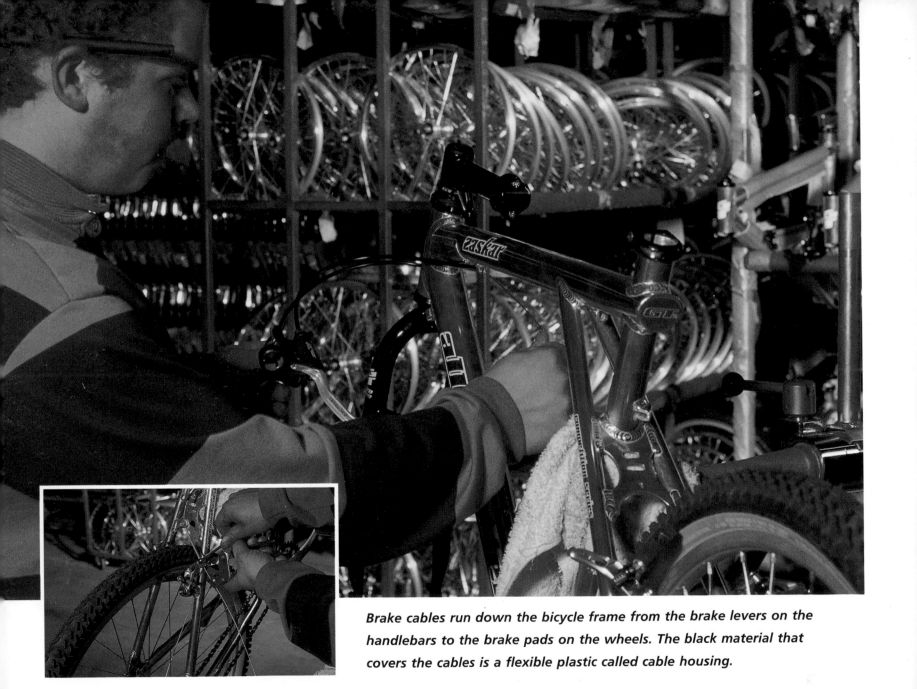

Brake cables run down the bicycle frame from the brake levers on the handlebars to the brake pads on the wheels. The black material that covers the cables is a flexible plastic called cable housing.

Stand next to your bike with both hands on the brake levers, as if you were riding. Roll the bike forward a little bit and then squeeze the brake levers all the way. The wheels should stop moving almost completely. If you can still roll your bicycle forward with both brake levers squeezed, then your brakes are mushy. Take your bicycle to the shop where you bought it and have the brakes adjusted.

From riding your bicycle, you know that it is harder to pedal uphill than on flat ground. It's also easier to pedal downhill. That's why most bicycles, including mountain bikes, have different gears. People usually refer to gears as speeds. When someone says he has a ten-speed bike, it means that his bike has ten different gears. Most mountain bikes sold today have either eighteen or twenty-one gears.

Each gear provides a different level of difficulty in pedaling your bicycle. You use lower gears when riding uphill because they make it easier to pedal. You change to higher gears going downhill because gravity is doing most of the work for you.

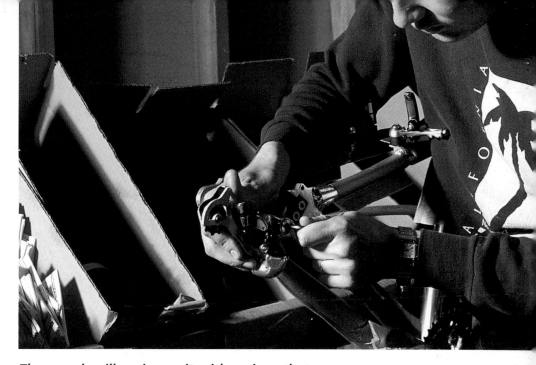

The rear derailleur is a unit with springs that can take up slack in the chain when the easier-to-pedal gears are in use and that gives more chain when the harder-to-pedal gears are in use. Two small screws called set screws, when tightened and loosened, allow the derailleur to reach the different rear sprockets.

Even if you didn't pedal at all, the bicycle would still roll down the hill. But if you want to pedal, your bike must be in a higher gear or else the wheels will turn faster than your feet can turn the pedals and cranks.

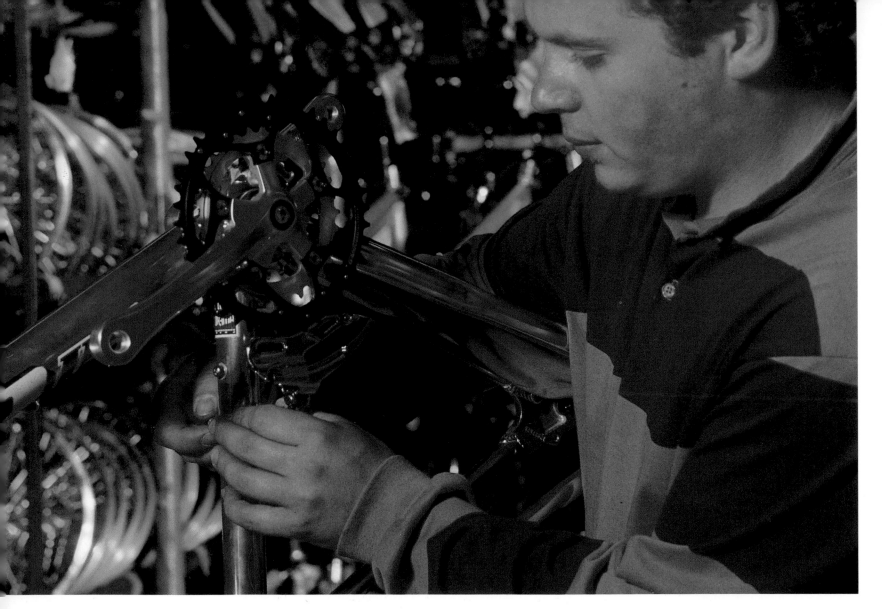

The front derailleur derails the chain from one set of sprockets to another. Like the sprockets on the rear wheel, the different sprockets on the front derailleur make it easier or harder to pedal.

Both the front and the rear derailleurs are activated by cables that attach to the handlebars. These cables run down the frame to the derailleurs and attach to them with a small bolt called a pinch bolt.

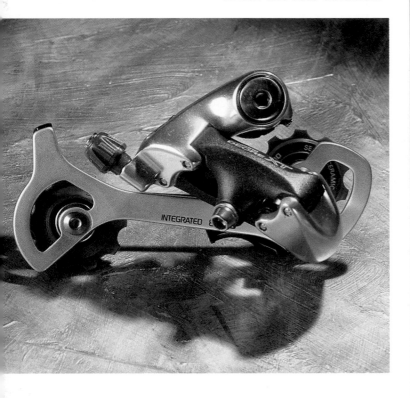

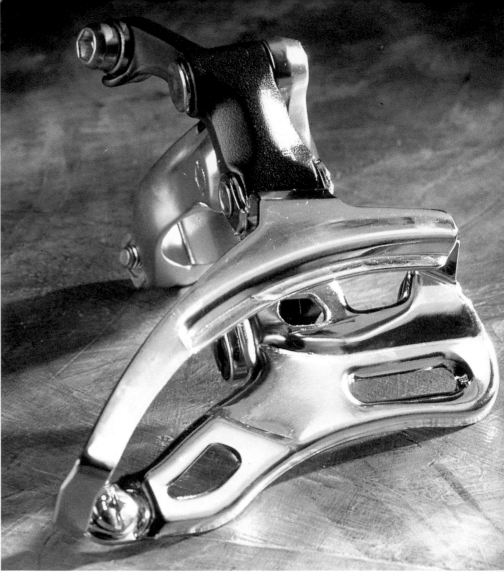

RIGHT: *The front derailleur*

The fork is like the arms of the mountain bike. These arms hold the front wheel and allow you to steer the bike in the direction you want to go.

FACING PAGE: *The fork attaches to the headset the same way the cranks attach to the bottom bracket, using cups and ball bearings. This ball-bearing assembly is what allows the handlebars and the front wheel to turn together.*

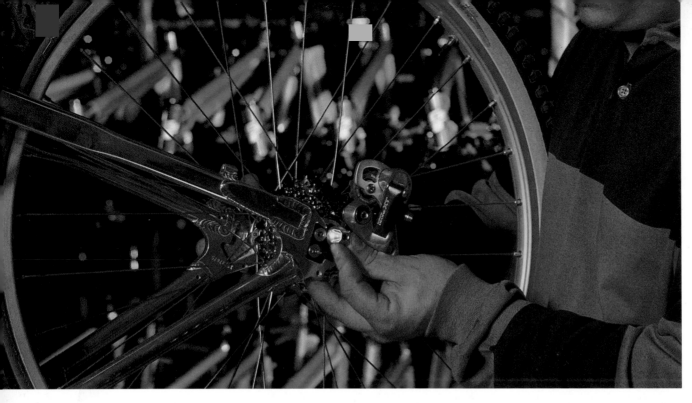

The quick release fits through the hollow axle of the wheel and pinches the wheel to the frame.

Unless you want to ride your bike in a straight line all the time, the fork is an important piece. Besides, if you couldn't turn the bike, you would have to ride around the world to get home! When you turn your handlebars to the left or to the right, you are also turning the fork and the front wheel.

Both the front and the rear wheels attach to the frame with a quick-release lever. If you need to take the wheel off, to repair a flat tire for example, you just loosen the quick-release lever and the wheel comes off easily. Without a quick release, you would have to use a wrench to loosen and tighten a nut on the wheel.

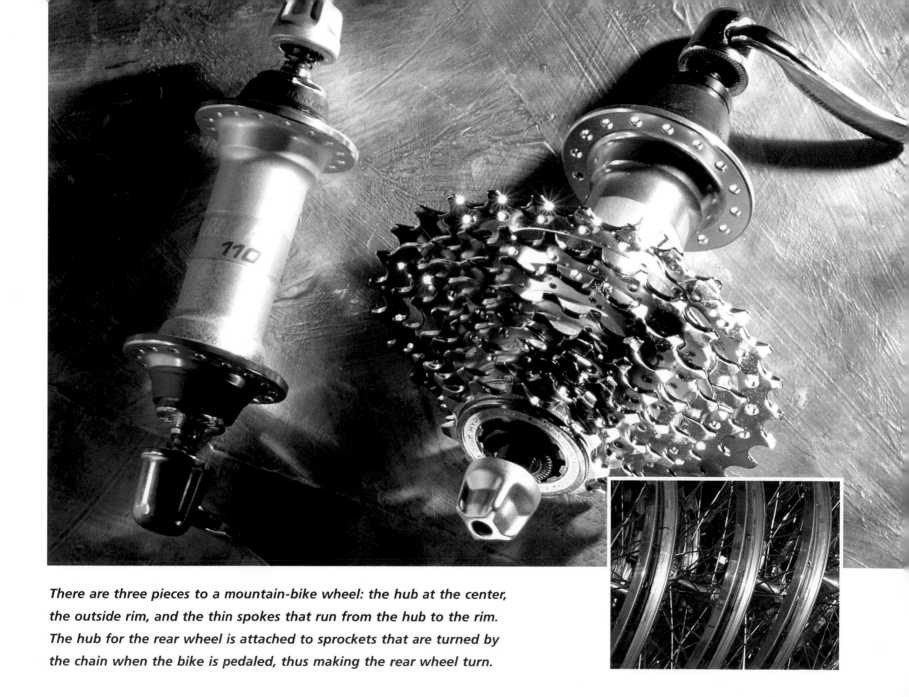

There are three pieces to a mountain-bike wheel: the hub at the center, the outside rim, and the thin spokes that run from the hub to the rim. The hub for the rear wheel is attached to sprockets that are turned by the chain when the bike is pedaled, thus making the rear wheel turn.

The first step in making a wheel is putting the spokes in the hub. The end of the spoke that sticks out of the hub is threaded like a screw.

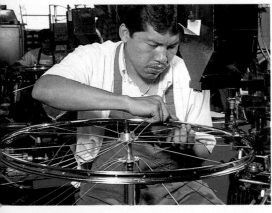

Next comes the lacing machine. The rim sits on three rollers, and the hub sits at the center. The machine puts a bolt through a hole in the rim onto the threaded end of the spoke. Each wheel has either thirty-two or thirty-six spokes.

At the factory, the inner tube and the tire are put on the finished wheel. The inner tube is what holds the air, and the tire is what holds the inner tube to the wheel.

An easy way to identify a type of bicycle is to look at the wheels and tires. Racing bikes have very thin, smooth tires. The less tire you have touching the ground, the faster the bike. Touring bikes look a lot like racing bikes, except the tires are a little wider because speed is less important if you're not racing. Bicycle Moto Cross, or BMX tires, are about the same width as mountain-bike tires. But the rims are much smaller in diameter. None of this means that one type of tire is better than another; they just have different purposes.

Except for the front wheel and the seat, which are put on the frame when it gets to the bike shop, everything is in place. It is now a mountain bike. But before it gets put in a box and sent to the bike shop for you to buy, it is checked out to make sure all parts are working properly. Is the bike shifting gears easily? Are the derailleurs working? Are the brakes tight enough? Too tight? Everything should work perfectly before it leaves the factory. That way, when you buy a mountain bike, you can ride it right out of the store.

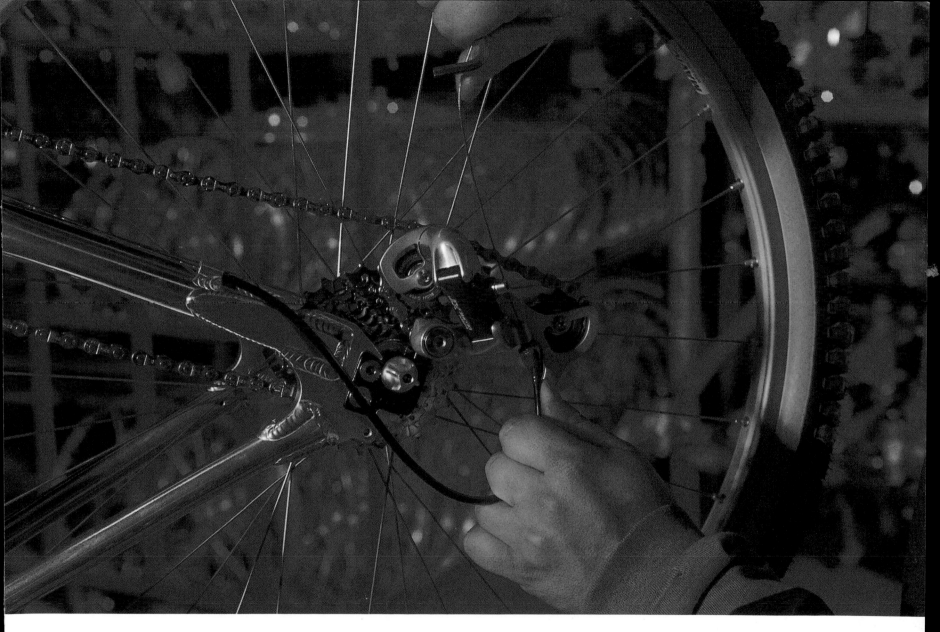

Things like the rear derailleur can shift around during the manufacturing process and even in the shipping to your bike shop. So they are checked and rechecked.

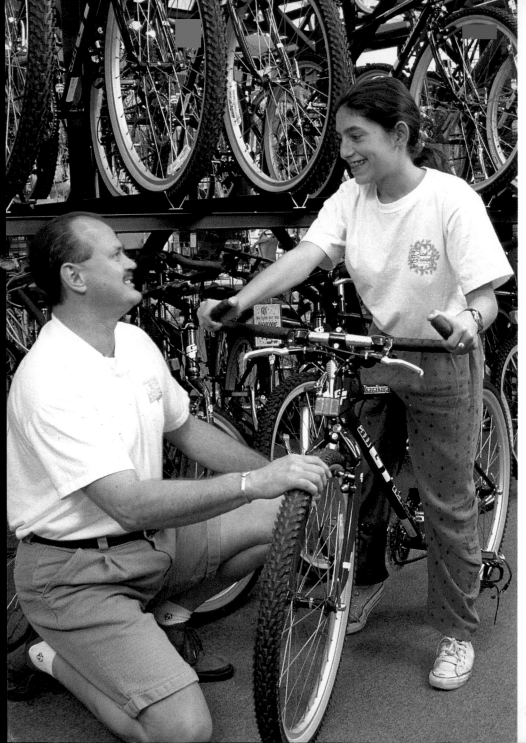

Buying the Right Size Bike

Sizing a bicycle frame depends on the type of bicycle you are buying. On a BMX bike, your feet should be able to reach the ground when you stand over the frame. For racing bikes, there should be about one and a half inches of clearance when you stand flat-footed over the top tube. For mountain bikes, the clearance should be about two inches. Girls' bicycle frames don't have a top tube to measure from, so just imagine one is there and use the same rules described above.

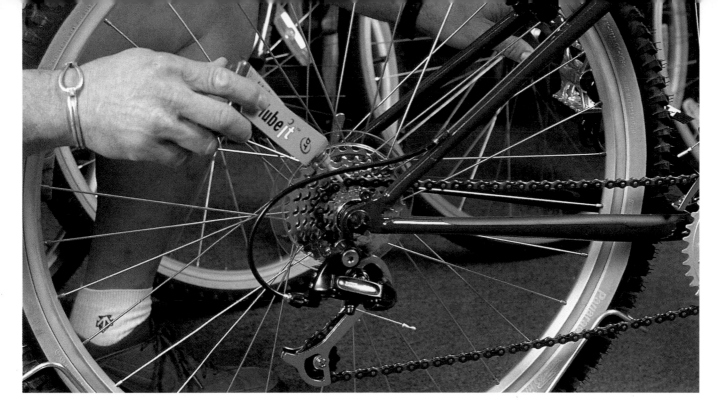

Maintaining a Bike

It's a good idea to buy your bicycle from a bike shop near your home. Most shops offer a service warranty that you should use if something on your bike doesn't feel or sound quite right. When you buy a new bike, take it back to the shop after riding your first twenty-five miles. The dealer will give it a tune-up and check for any problems the factory might have missed. Don't try to repair it yourself or let friends repair it for you.

You can do some minor bike maintainance such as keeping the chain well lubricated. But beware, improper lubricating can damage your bike. Ask someone at your bike shop to show you which parts you should and shouldn't lubricate. One rule of thumb: Never put oil on ball bearings that already have lubrication, like those on the hubs, bottom bracket, and the headset.

Bicycle Riding Safety

When a car is on the road, it has to follow certain rules. There are traffic lights telling the driver when to go and when to stop. All cars and trucks have blinkers that the driver must use when he is making a turn. This warns other drivers so they don't run into each other.

When you are riding your bicycle on the road or in the street, you have to follow the same traffic rules as cars do. You have to stop at red lights and at stop signs. People crossing the street always have the right of way, and you must stop if they are in the street, just as a car does. And when you are making a turn, you must signal other bike riders and cars about your turn. Since you don't have blinkers, you use hand signals.

Never ride a bike without a helmet. You can get seriously hurt if you fall off your bike and hit your head. You should also wear a good pair of padded bicycle riding gloves. They make your ride more comfortable and help cushion your hands when you go over bumps. It's also a good idea to wear something over your eyes. It can be pretty dangerous when something gets in your eye while riding. Bike riders often tell one another to "ride safe." So from one bike rider to another, RIDE SAFE!

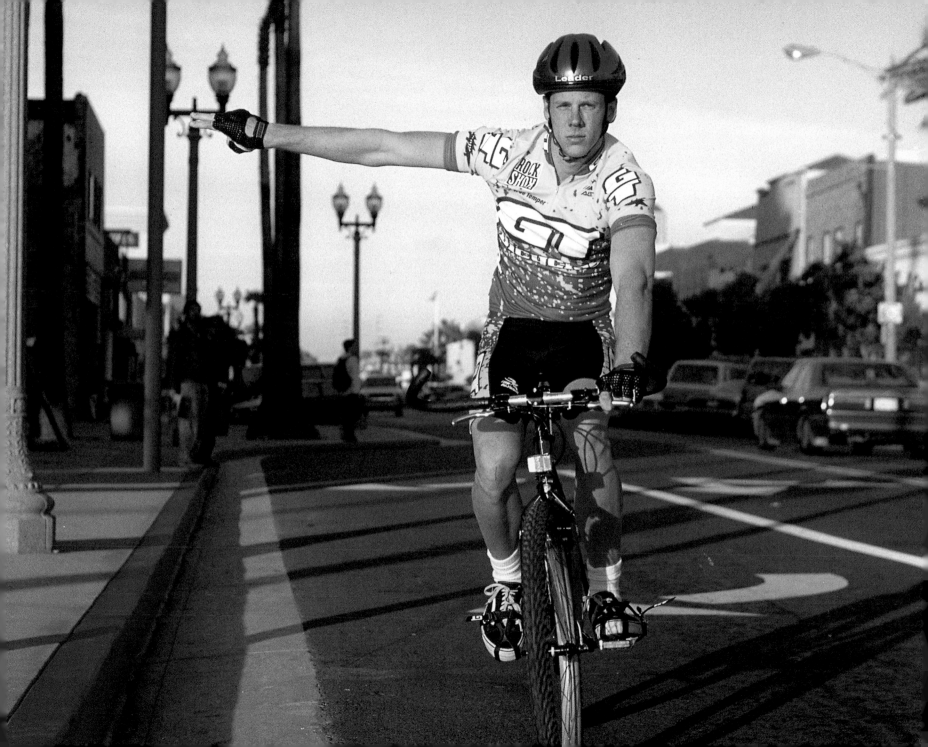

Index

About the Author

DAVID HAUTZIG is an avid cyclist as well as a great fan of the sport, and he has always been fascinated by the mechanics of the bicycle. This book was a perfect opportunity for him to combine his hobby with his career as a writer and photographer. Mr. Hautzig was born and raised in New York City and is the photographer of the A World of My Own series written by Kathleen Krull, and most recently the author and photographer of *A Thousand Miles in Twelve Days: Pro Cyclists on Tour.*